Van Gogh

TASCHEN

KÖLN LONDON MADRID NEW YORK PARIS TOKYO

Vincent van Gogh (1853–1890)

"This man will either go mad or he will outstrip us all." Such was the fate that Camille Pissarro, the great Impressionist painter, predicted for his colleague Vincent van Gogh, a struggling artist still vainly seeking a buyer for his pictures. He was to prove right on both counts. Van Gogh was born in Groot-Zundert, near Breda, the eldest son of a Dutch pastor. He tried his hand at numerous professions, working as an art dealer, a teacher, a lay preacher and a book-seller before finally embarking, largely self-trained, upon a career as an artist. All his life, however, he remained a solitary and despairing figure, and his self-destructive nature drove him in his later years to the brink of madness.

Feeling himself alone in the world, his only true friend and source of moral and financial support was his brother Theo, who attended van Gogh's welfare throughout his life and who would ultimately follow him, within the space of six short months, to the grave. The recognition and admiration for which van Gogh fought so bitterly would only be granted him after the self-inflicted revolver shot which ended his tragic life.

Today, van Gogh is not only considered the most important pioneer of 20th-century art, but is widely regarded as one of the most significant and best-loved painters in the entire history of art.

„Dieser Mann wird entweder verrückt, oder er läßt uns alle weit hinter sich." Das hatte der große impressionistische Maler Camille Pissarro seinem Kollegen Vincent van Gogh prophezeit, als dieser noch immer vergeblich versuchte, einen Käufer für seine Bilder zu finden. In beidem sollte er recht behalten. Der in Groot-Zundert bei Breda geborene niederländische Pfarrerssohn, der sich in den verschiedensten Berufen versuchte, ehe er den Schritt zum Künstler wagte, blieb sein Leben lang ein einsamer und verzweifelter Einzelgänger, und sein selbstzerstörerischer Charakter trieb ihn gegen Ende seines Lebens zumindest an den Rand des Wahnsinns.

Mit sich und der Welt allein gelassen, fand er einen wirklichen Freund nur in seinem Bruder Theo, der ihn ein Leben lang umsorgte und ihm ein halbes Jahr nach seinem Tod ins Grab folgte. Die Anerkennung und Verehrung, um die Vincent van Gogh so bitter rang, ereilte ihn erst nach seinem tragischen Tod durch einen Revolverschuß, den er sich selbst beigebracht hatte.

Heute gilt van Gogh nicht nur als wichtigster Wegbereiter der Malerei des 20. Jahrhunderts, sondern auch als einer der bedeutendsten und beliebtesten Maler der gesamten Kunstgeschichte.

« Ou bien cet homme deviendra fou ou bien il nous devancera tous. » C'est ce que prédit Camille Pissarro, le grand peintre impressionniste, à son ami Vincent van Gogh, à l'époque où ce dernier s'évertuait à trouver acheteur à ses toiles. Ces deux prophéties se réalisèrent. Ce fils de pasteur né à Groot-Zundert, près de Breda, qui s'essaya à toutes sortes de petits métiers avant de se risquer à la peinture, fut sa vie entière un homme solitaire et désespéré, que son caractère auto-destructeur poussa, du moins vers la fin de sa vie, au bord de la folie.

Abandonné de tous, il ne connut qu'un seul et véritable ami en la personne de son frère, Théo, qui l'entretint sa vie durant et qui, à quelques mois près, l'accompagna même dans la mort. L'estime et la considération, que Van Gogh ne cessa de rechercher âprement, ne lui furent accordées qu'après sa mort tragique, mort qu'il se donna lui-même par balle.

Aujourd'hui, Van Gogh ne fait pas uniquement figure de principal précurseur de la peinture du XXe siècle, il compte également parmi les artistes les plus importants et les plus appréciés de l'histoire de l'art.

«O este hombre se volverá loco, o nos dejará a todos muy atrás». Así predijo el gran pintor impresionista Camille Pissarro el destino de su colega Vincent van Gogh, cuando este último todavía trataba en vano de encontrar un comprador para sus telas. En realidad, se cumplieron ambas profecías. Van Gogh nació en Groot-Zundert, cerca de Breda, siendo el primogénito de un pastor holandés. Probó su suerte en diversas profesiones, antes de dedicarse a la pintura, y fue durante toda su vida un hombre solitario y desesperado, cuya tendencia a la autodestrucción lo llevó al borde de la locura en los últimos años de su existencia.

Abandonado por todos, su único y verdadero amigo fue su hermano Theo, quien le ofreció constantemente su apoyo moral y financiero y le siguió hasta en la muerte, pues falleció pocos meses después. El reconocimiento y el respeto que persiguió tenazmente durante toda su vida sólo le fueron otorgados después de su trágica desaparición, provocada por su propia mano, con un tiro de revólver.

Hoy, van Gogh no sólo es considerado como el precursor más importante de la pintura del siglo XX, sino también como uno de los pintores más destacados y apreciados en toda la historia del arte.

Printed in China
ISBN 3-8228-1419-9

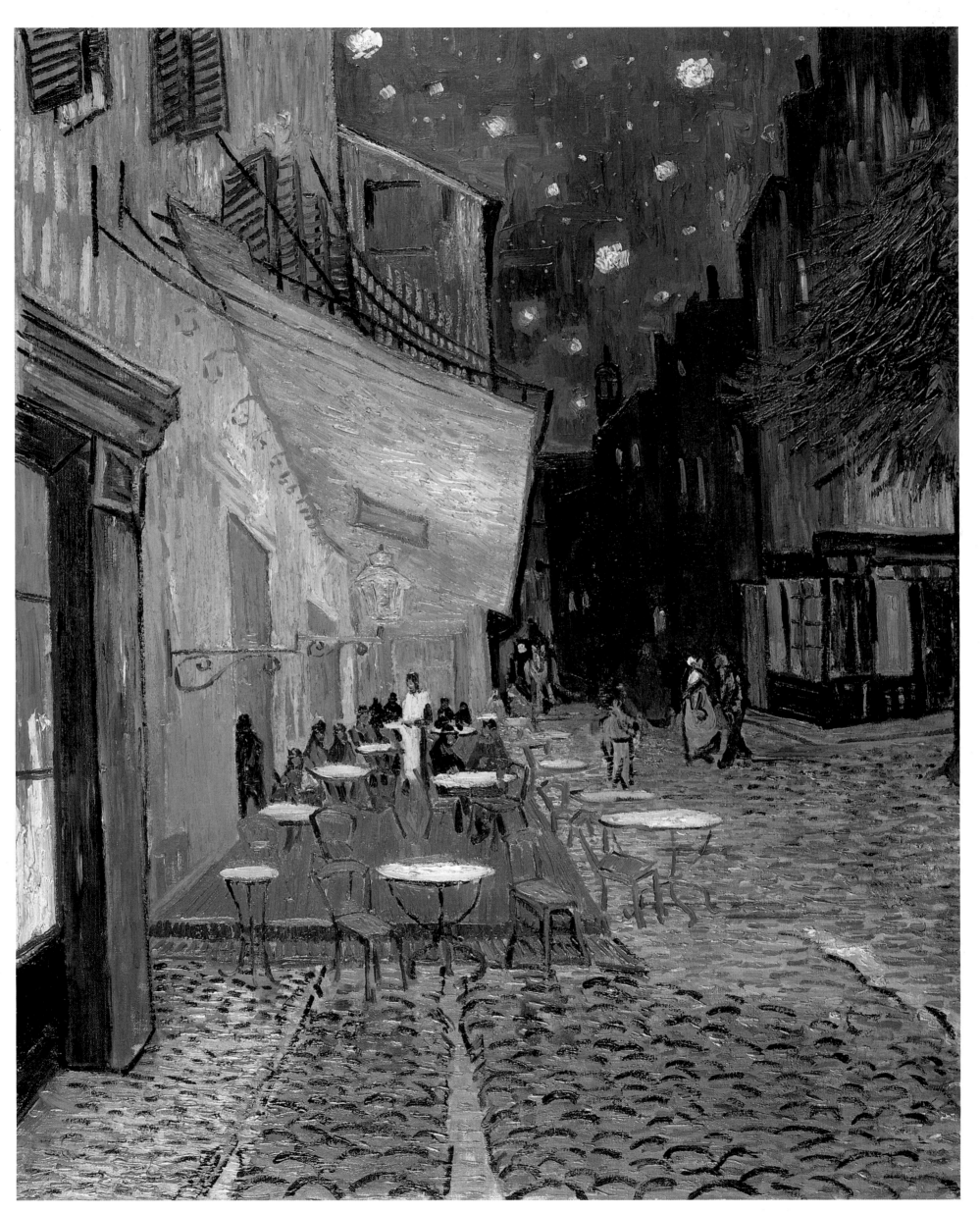

Vincent van Gogh · The Café Terrace on the Place du Forum in Arles

Vincent van Gogh
The Café Terrace on the Place du Forum in Arles, 1888
Terrasse des Cafés an der Place du Forum in Arles
Terrasse du cafésur la Place du Forum à Arles
Terraza del café de la Place du Forum en Arles

Oil on canvas, 81 x 65.5 cm
Otterlo, Rijksmuseum Kröller-Möller

A café in the evening, seen from the outside; on the terrace people are seated. An enormous yellow lamp lights up the terrace, the house fronts and the pavement, and casts its light onto the street cobbles, which take on pink-violet colouring.

Ein Café am Abend, von außen gesehen. Auf der Terrasse sitzen Personen. Eine riesige gelbe Laterne beleuchtet die Terrasse, die Vorderseite des Hauses, den Gehsteig, und wirft ihr Licht sogar aufs Straßenpflaster, das eine rosaviolette Tönung annimmt.

Un café, le soir, vu de l'extérieur. Quelques personnes sont assises à la terrasse. Un énorme lampadaire jaune éclaire la terrasse, la façade de la maison, le trottoir et projette même sa lumière sur le pavé de la rue qui prend une coloration rose violet.

Un café por la noche, visto desde fuera. En la terraza están sentadas personas. Un enorme farol amarillo ilumina la terraza, la fachada de la casa, la acera, e incluso extiende su resplandor hasta la calle adoquinada que adquiere una tonalidad rosa-violeta.

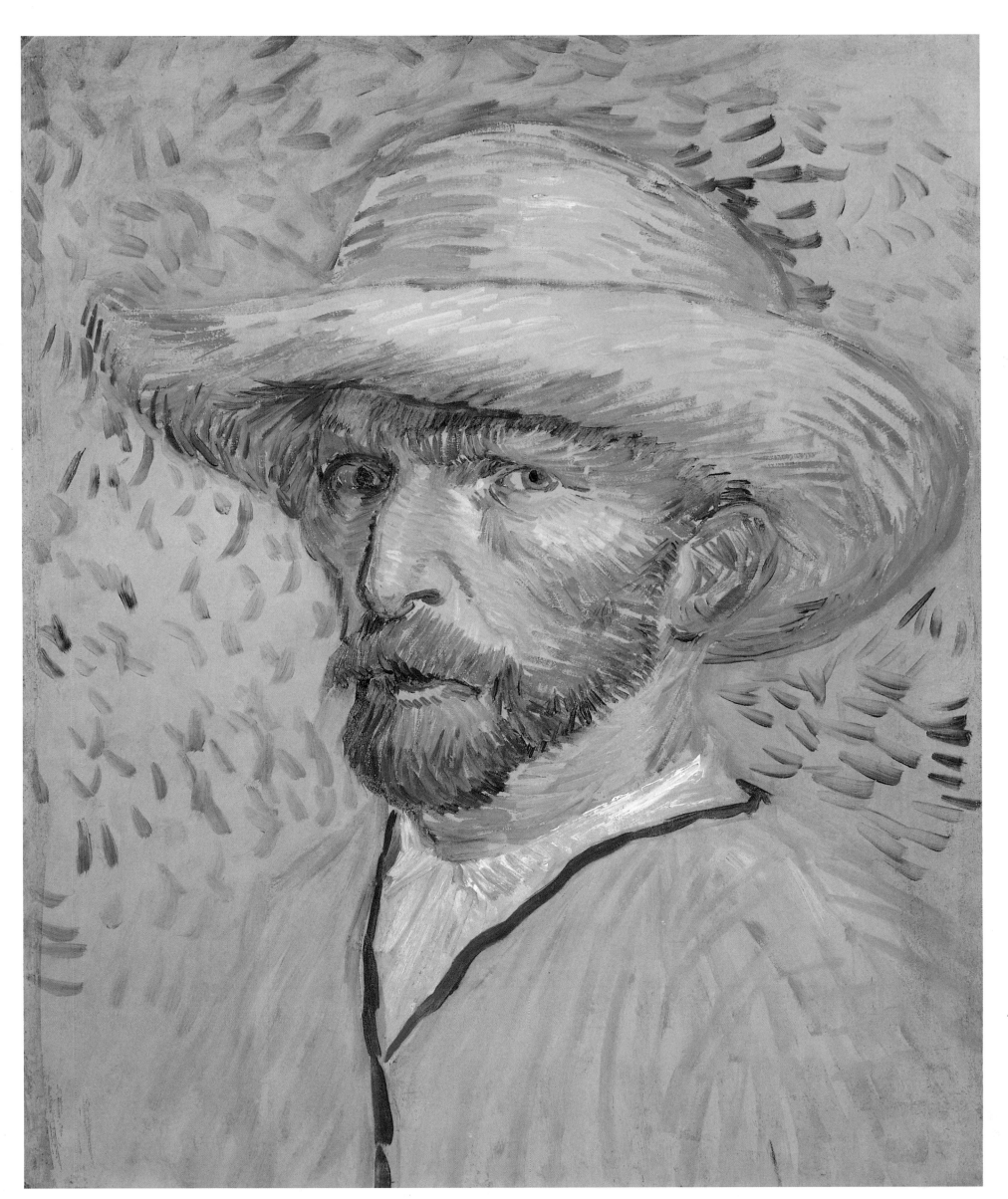

Vincent van Gogh · Self-Portrait with Straw Hat

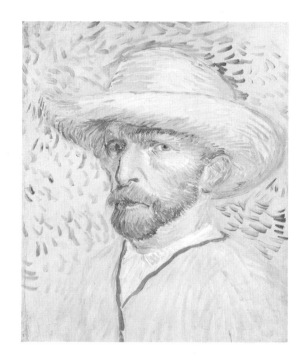

Vincent van Gogh
Self-Portrait with Straw Hat, summer 1887
Selbstbildnis mit Strohhut
Autoportrait au chapeau de paille
Auttoretrato con sombrero de paja

Oil on pasteboard with flat cradling, 40.5 x 32.5 cm
Amsterdam, van Gogh Museum

"This man will either go mad or he will outstrip us all."

„Dieser Mann wird entweder verrückt, oder er läßt uns alle weit hinter sich."

« Ou bien cet homme deviendra fou ou bien il nous devancera tous. »

« O este hombre se volverá loco, o nos dejará a todos muy atrás».

CAMILLE PISSARRO

© 2001 TASCHEN GmbH
Hohenzollernring 53, D–50672 Köln
www.taschen.com
© van Gogh Museum Amsterdam
Photograph © Vincent van Gogh Foundation

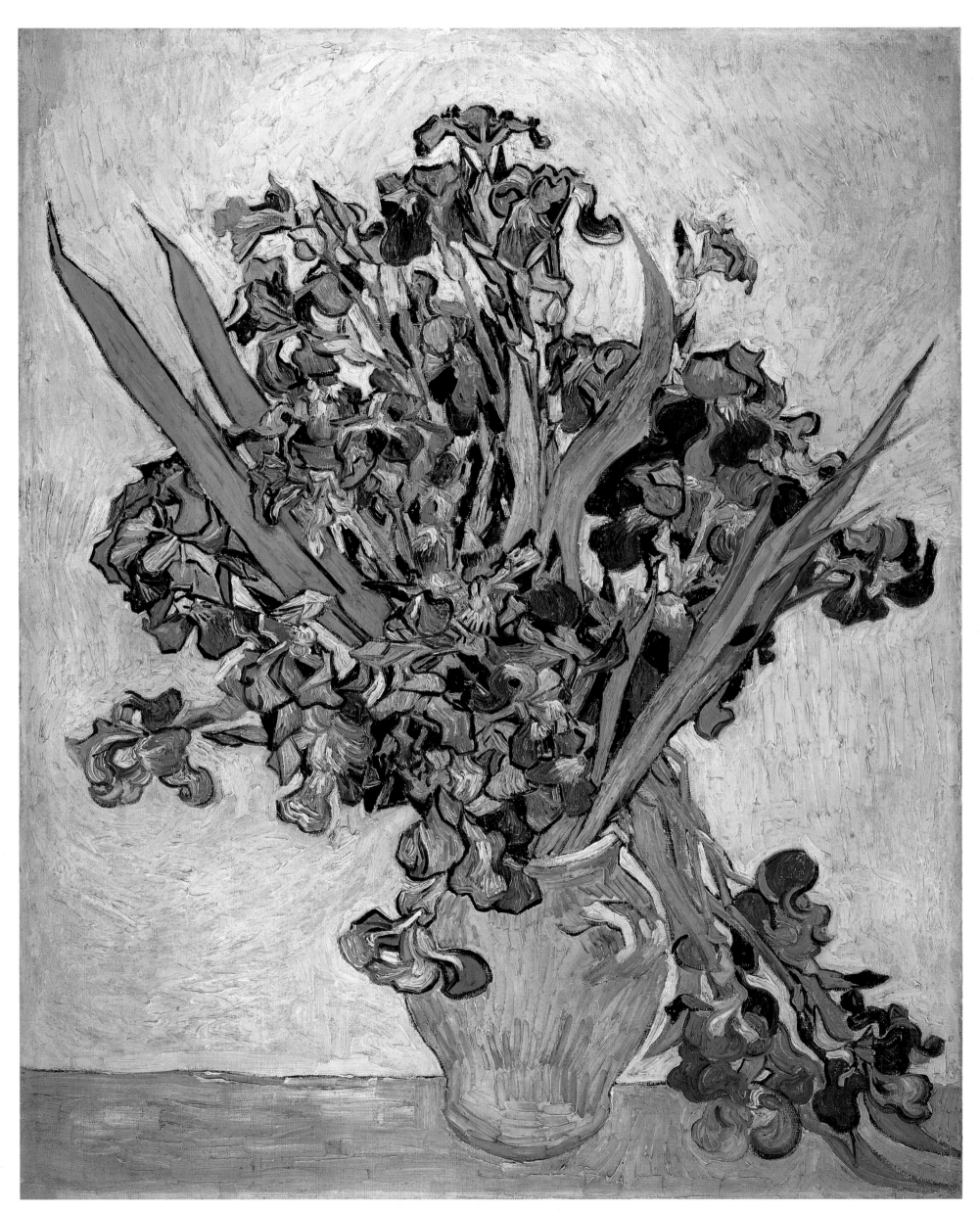

Vincent van Gogh · Vase with Irises against a Yellow Background

Vincent van Gogh
Vase with Irises against a Yellow Background, Saint-Rémy, May 1890
Vase mit Iris vor gelbem Hintergrund
Vase avec iris sur fond jaune
Jarrón con lirios sobre un fondo amarillo

Oil on canvas, 92 x 73.5 cm
Amsterdam, van Gogh Museum

"Now we're experiencing a glorious heat wave without any wind – that just suits me. A sun, a light, which for lack of a better word can only be called yellow, pale sulphurous yellow, pale lemon gold. Oh, how lovely this yellow is."

„Jetzt haben wir hier eine glorreiche, gewaltige Hitze ohne Wind, das ist etwas für mich. Eine Sonne, ein Licht, das ich mangels besserer Bezeichnung nur gelb, blasses Schwefelgelb, blasses Zitronengold nennen kann. Ach, schön ist das Gelb."

« Maintenant, nous avons ici une canicule glorieuse sans vent, cela me convient bien : un soleil, une lumière que je ne peux qualifier, à défaut de mieux que de jaune, jaune soufre pâle. Ah! Comme le jaune est beau. »

«Ahora tenemos por aquí un calor espléndido, intenso y sin viento, lo que me viene muy bien. Un sol, una luz que a falta de mejor cosa no puedo llamar más que amarilla; amarillo de azufre pálido, limón pálido oro. ¡Qué hermoso es el amarillo!»

VINCENT VAN GOGH

Vincent van Gogh · Vincent's Bedroom in Arles

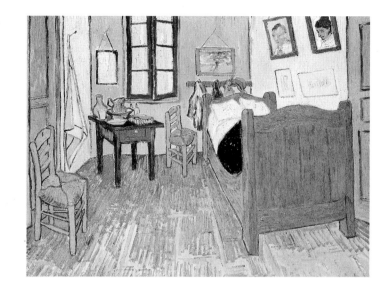

Vincent van Gogh
Vincent's Bedroom in Arles, 1899
Vincents Schlafzimmer in Arles
La chambre de Vincent à Arles
La habitación de Vincent en Arles

Oil on canvas, 56.5 x 74 cm
Paris, Musée d'Orsay

"This time it's quite simply my bedroom – here colour is everything; objects are given a greater style by simplifying them; thereby giving the impression of peace and, in the broad sense, of sleep."

„Diesmal ist es ganz einfach mein Schlafzimmer, hier muß es nur die Farbe machen; indem ich durch Vereinfachung den Dingen einen größeren Stil gebe, soll einem der Gedanke an Ruhe oder ganz allgemein an Schlaf kommen."

« Cette fois, c'est tout simplement ma chambre à coucher, ici, c'est la couleur qui doit rendre l'effet. En donnant un plus grand style aux choses par leur simplification, l'idée de tranquillité et, en général, de sommeil doit être suggérée. »

«Esta vez es simplemente mi dormitorio y lo único que tiene que destacar es el color; la simplificación proporciona a los objetos un mayor estilo, y con ello pretendo trasmitir una sensación de tranquilidad o, en general, de sueño».

VINCENT VAN GOGH

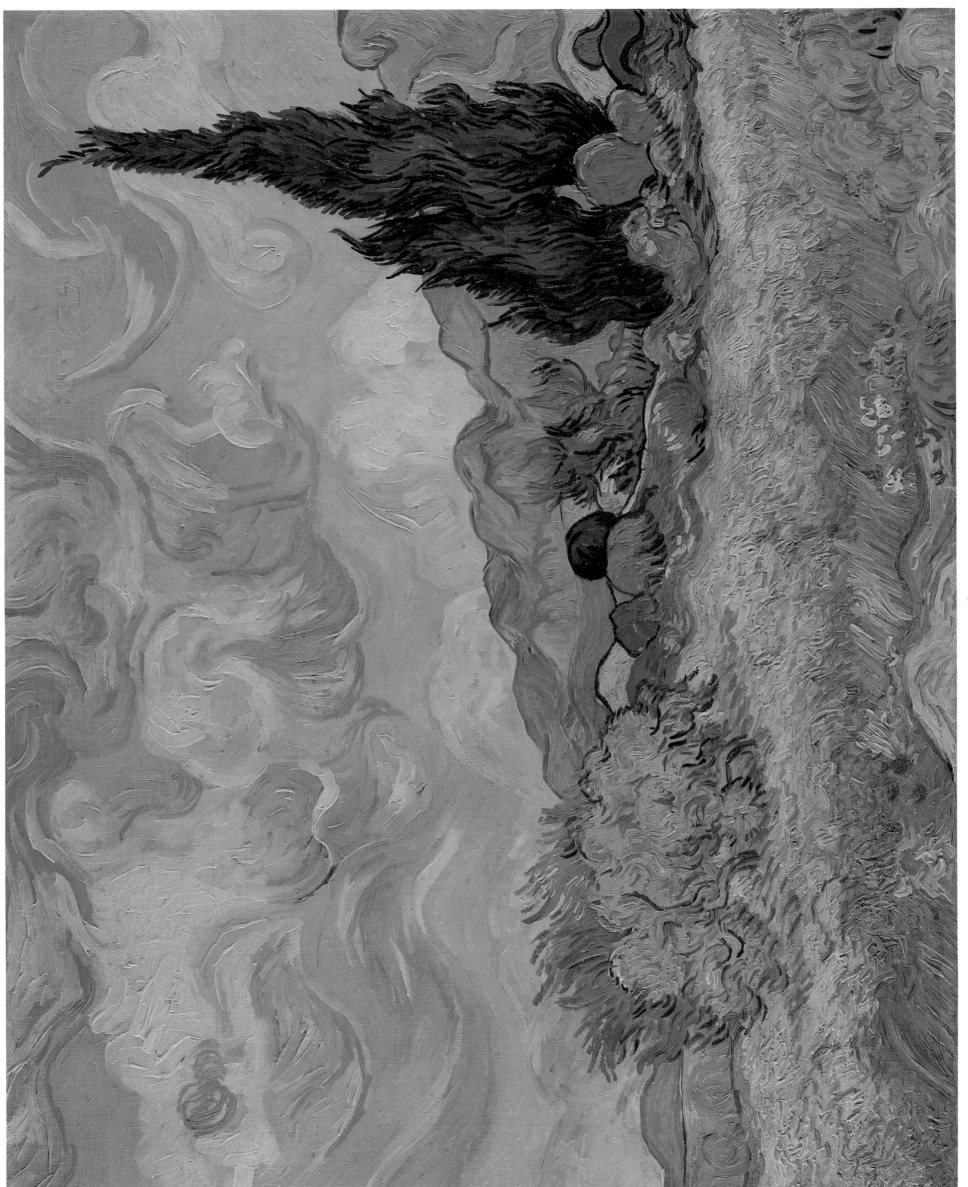

Vincent van Gogh · Wheat Field with Cypresses

Vincent van Gogh
Wheat Field with Cypresses, 1889
Weizenfeld mit Zypressen
Les blés jaunes aux cyprès
Trigal con cipreses

Oil on canvas, 72.5 x 91.5 cm
London, National Gallery

"There are endless corn fields under dull skies, and I've not shied away from portraying this sadness and utter loneliness ... I believe these pictures will tell you what I am not able to express in words – namely that which I view as healthy and inspiring in rural life."

„Es sind endlos weite Kornfelder unter trüben Himmeln, und ich habe den Versuch nicht gescheut, Traurigkeit und äußerste Einsamkeit auszudrücken ... Ich glaube fast diese Bilder werden Euch sagen, was ich in Worten nicht sagen kann, nämlich was ich Gesundes und Kraft-gebendes im Landleben erblicke."

« Ce sont des champs de blé immenses et à perte de vue sous des cieux brouillés, et j'ai osé essayer d'exprimer la tristesse et la plus grande des solitudes... Je croirais presque que ces tableaux vous diront ce que je ne peux pas exprimer par des mots et qui serait en effet ce que je peux observer de sain et de dispensateur de force dans la vie champêtre. »

«Son campos de trigo interminables bajo un cielo encapotado, y he puesto todo mi empeño en expresar tristeza y una soledad absoluta... Tengo casi la certidumbre de que estos cuadros os transmitirán lo que yo no puedo expresar con palabras, todo lo sano y fortificante que descubro en la vida rural».

VINCENT VAN GOGH

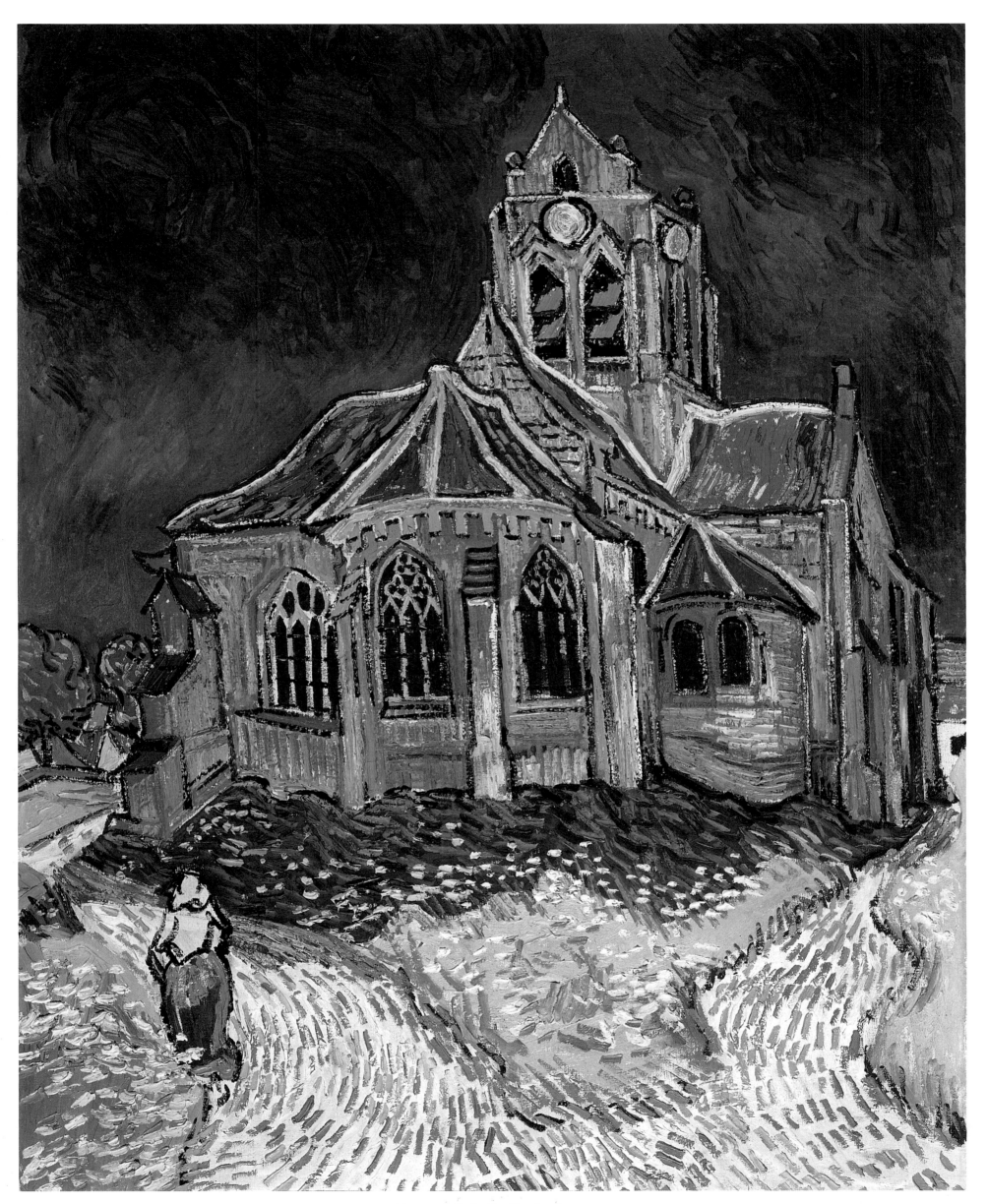

Vincent van Gogh · The Church at Auvers

Vincent van Gogh
The Church at Auvers, 1890
Die Kirche von Auvers
L'église d'Auvers
La iglesia de Auvers

Oil on canvas, 94 x 74 cm
Paris, Musée d'Orsay

"I painted a large picture of the village church – the building appears violet against a flat, deep blue sky of pure colour; the stained glass windows are like ultramarine coloured flecks; the roof is violet and orange in parts."

„Es entstand auch ein großes Bild der Dorfkirche, auf dem das Gebäude violett vor einem flächigen, tiefblauen Himmel aus reinem Kolorit erscheint; die farbigen Glasfenster sind wie Flecke aus Ultramarin, das Dach ist violett und zum Teil orange."

« Il est né aussi un grand tableau de l'église du village, sur lequel l'édifice apparaît dans un pur coloris, violet, devant un ciel à la surface bleu foncé. Les vitraux de couleurs sont comme des taches d'outre-mer, le toit est violet et en partie rouge. »

«También he pintado un cuadro grande de la iglesia del pueblo, en el que aparece el edificio en tonos violetas, recortándose ante un cielo de un azul profundo, de un color puro; las vidrieras son como manchas de una tonalidad ultramarina; el tejado es violeta con una parte anaranjada».

VINCENT VAN GOGH

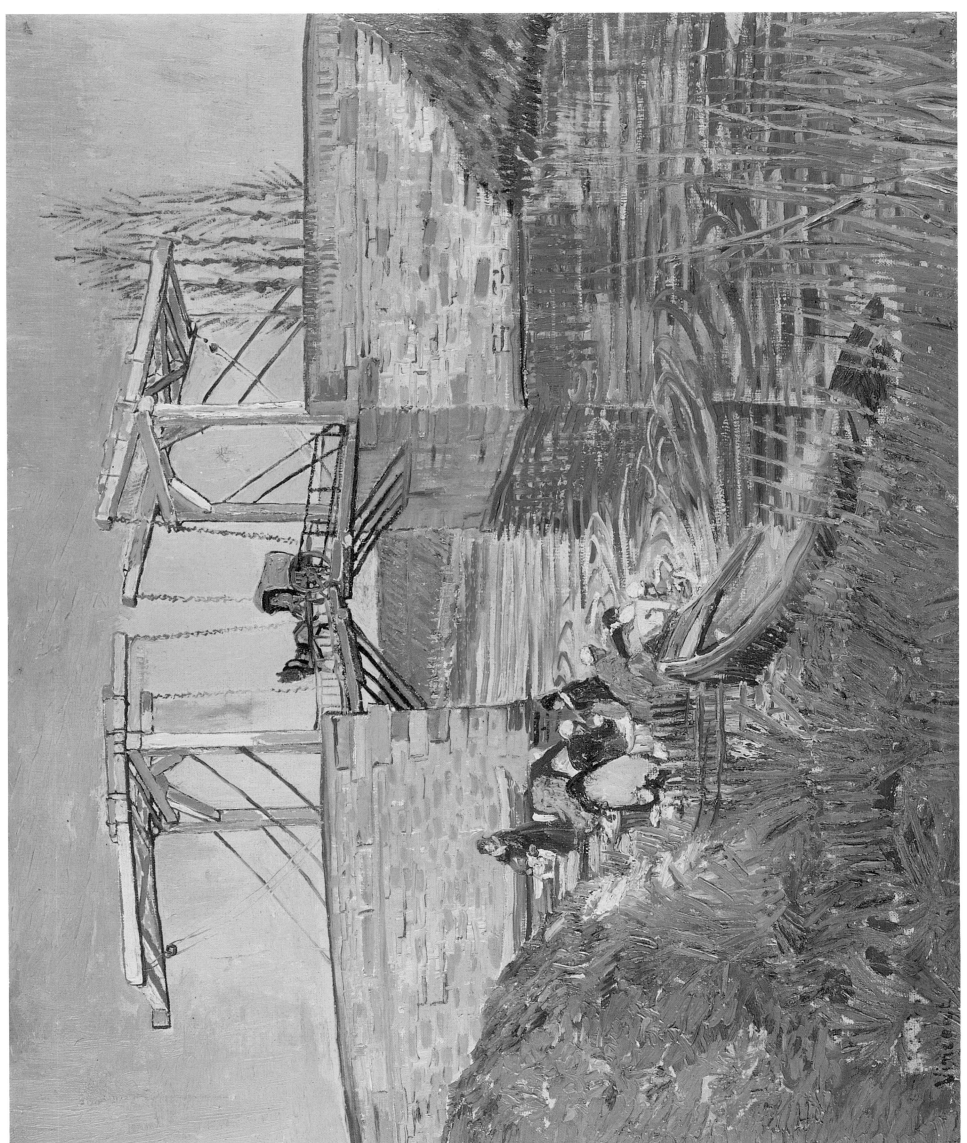

Vincent van Gogh
Drawbridge at Arles. "Pont de Langlois", 1888
Die Brücke bei Arles. „Pont de Langlois"
Le pont de Langlois, près d'Arles
El puente de Arles. «Pont de Langlois»

Oil on canvas, 54 x 65 cm
Otterlo, Stichting Kröller-Müller Museum

Perhaps he was reminded of his Dutch homeland – at any rate van Gogh was
drawn more and more to the canal, south of Arles, where he studied the
bridge and its surroundings.

Vielleicht fühlte er sich an die holländische Heimat erinnert: Jedenfalls
zog es van Gogh immer wieder an den Kanal südlich von Arles, um die
Brücke und die Umgebung zu studieren.

Sans doute vivait-il aussi dans le souvenir de la Hollande, son pays natal; Van
Gogh se rendait souvent au sud d'Arles, le long du canal, et faisait des croquis
du pont et des alentours.

Quizás porque le recordase su patria holandesa, van Gogh se siente
fuertemente atraído por el canal al sur de Arles, donde se dedica a hacer
estudios del puente y los alrededores.

Vincent van Gogh · Sower (After Millet)

Vincent van Gogh
Sower (after Millet), 1888
Der Sämann (nach Millet)
Le semeur (d'après Millet)
El sembrador (según Millet)

Oil on canvas, 65 x 80.5 cm
Otterlo, Stichting Kröller-Müller Museum

"I don't in fact invent the whole painting; on the contrary, I discover the
thing, but it must come out of nature."

„Ich erfinde eben nicht das ganze Bild, im Gegenteil, ich finde es fertig vor,
aber es muß aus der Natur herausgeschält werden."

« Je n'invente pas l'œuvre toute entière, au contraire, je la trouve là, terminée,
mais il faut que je la sorte de la nature en la décortiquant. »

«Y es que el cuadro entero no es una invención mía; al contrario, lo encuentro
ya terminado, pero hay que despojarlo de la naturaleza».

VINCENT VAN GOGH

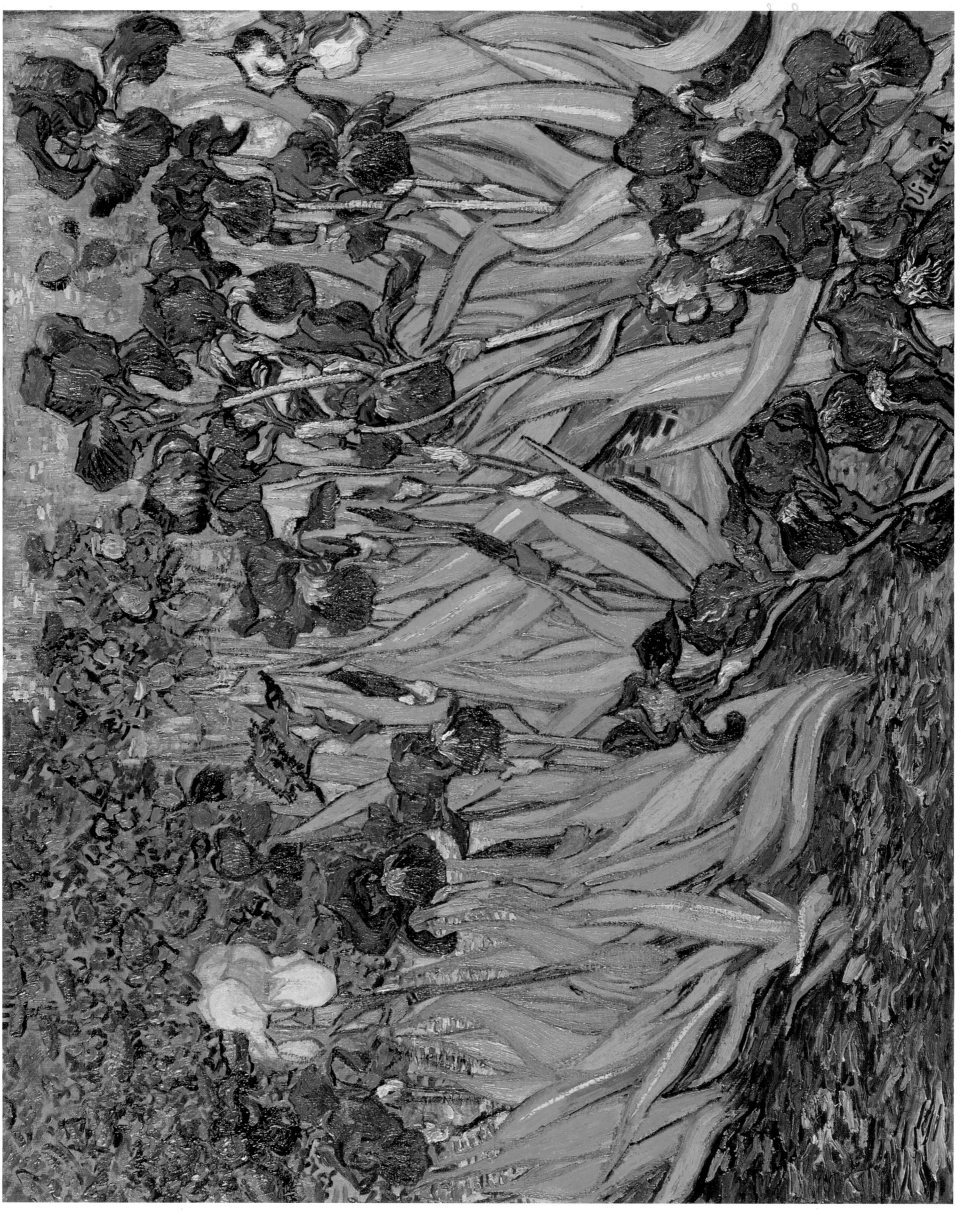

Vincent van Gogh · Irises

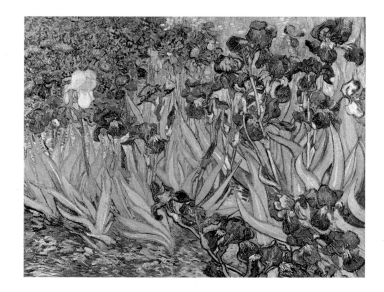

Vincent van Gogh
Irises, 1889
Iris
Iris
Lirios

Oil on canvas, 71 x 93 cm
Malibu (CA.), J. Paul Getty Museum

One of his first paintings done in Saint-Rémy is close to his flower paintings of Arles: Irises. He came across this motif of voluptuous irises on his way to Dr. Paul Gachet's flat.

Eines seiner ersten Bilder aus Saint-Rémy, mit dem er zugleich an die Blumenbilder aus Arles anknüpft, sind die Schwertlilien. Das Motiv hatte er an dem von üppigen Schwertlilien umfaßten Weg zur Wohnung seines Arztes Dr. Paul Gachet gefunden.

L'une de ses toutes premières compositions effectuées à Saint-Rémy et par laquelle il allait continuer sa série de fleurs peintes à Arles, est la toile intitulée Iris. Le motif s'inspire des mêmes fleurs qui ornaient à profusion le chemin conduisant à l'appartement du docteur Paul Gachet.

Una de las primeras obras que pintó en Saint-Rémy se titula Lirios y es una continuación de los cuadros de flores realizados en Arles. El motivo lo había encontrado en el camino, bordeado de exuberantes lirios cárdenos, que llevaba a la casa de su médico, el Dr. Paul Gachet.

Vincent van Gogh · Noon: Rest from Work (after Millet)

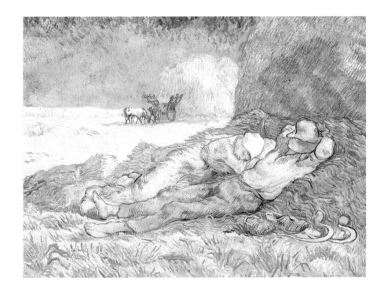

Vincent van Gogh
Noon: Rest from Work (after Millet), 1890
Mittagsrast (nach Millet)
La méridienne ou La sieste (d'après Millet)
La siesta (según Millet)

Oil on canvas, 73 x 91 cm
Paris, Musée d'Orsay

"I have drawn into myself so much that I literally do not see any other people anymore excepting the peasants with whom I have direct contact, because I paint them."

„Ich ziehe mich dermaßen zurück, daß ich buchstäblich keine anderen Menschen mehr sehe als die Bauern, mit denen ich unmittelbar zu tun habe, weil ich sie male."

« Je me replie tellement sur moi-même que je ne vois plus aucune autre personne que celles avec lesquelles j'ai directement à faire c'est-à-dire avec les paysans que je peins. »

«Llevo una vida tan retraída que literalmente las únicas personas a las que veo son los campesinos con los que trato porque los pinto».

VINCENT VAN GOGH

© 2001 TASCHEN GmbH
Hohenzollernring 53, D–50672 Köln
www.taschen.com
Photo: RMN

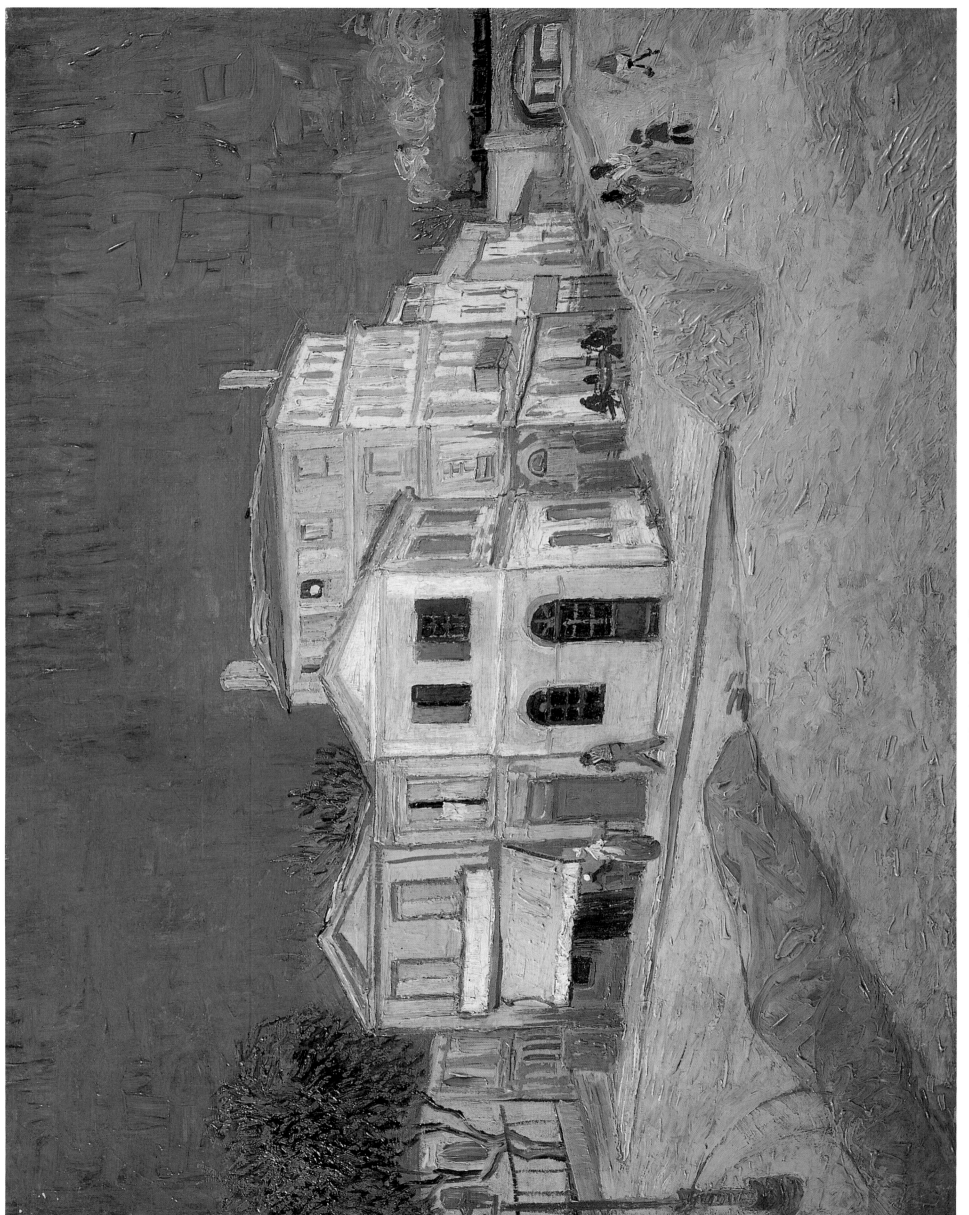

Vincent van Gogh · The Yellow House (Vincent's House)

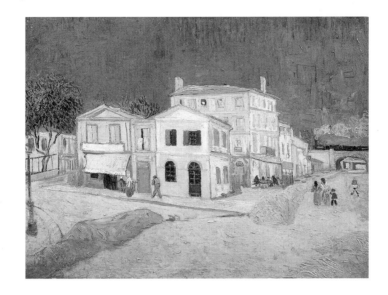

Vincent van Gogh
The Yellow House (Vincent's House), 1888
Das gelbe Haus (Vincents Haus)
La maison jaune (La maison de Vincent)
La casa amarilla (La casa de Vincent)

Oil on canvas, 72 x 91.5 cm
Amsterdam, van Gogh Museum

"My house here is painted butter yellow on the outside and has solid green window shutters;
it is located directly in a square with a green park full of planetrees, oleanders and acacias."

„Mein Haus hier ist außen buttergelb gestrichen und hat hartgrüne Fensterläden, es liegt mitten
in der Sonne an einem Platz, an dem auch ein grüner Park ist mit Platanen, Oleander, Akazien."

« L'extérieur de ma maison ici est peint en jaune beurre et est dotée de volets d'un vert soutenu.
Elle est située en plein soleil, sur une place où se trouve aussi un parc verdoyant, avec des
platanes, des lauriers-roses et des acacias. »

«Mi casa aquí está pintada por fuera de un amarillo manteca y las contraventanas son de un verde
fuerte. Está situada a pleno sol, en una plaza donde también hay un parque verde con plátanos,
adelfas y acacias».

VINCENT VAN GOGH

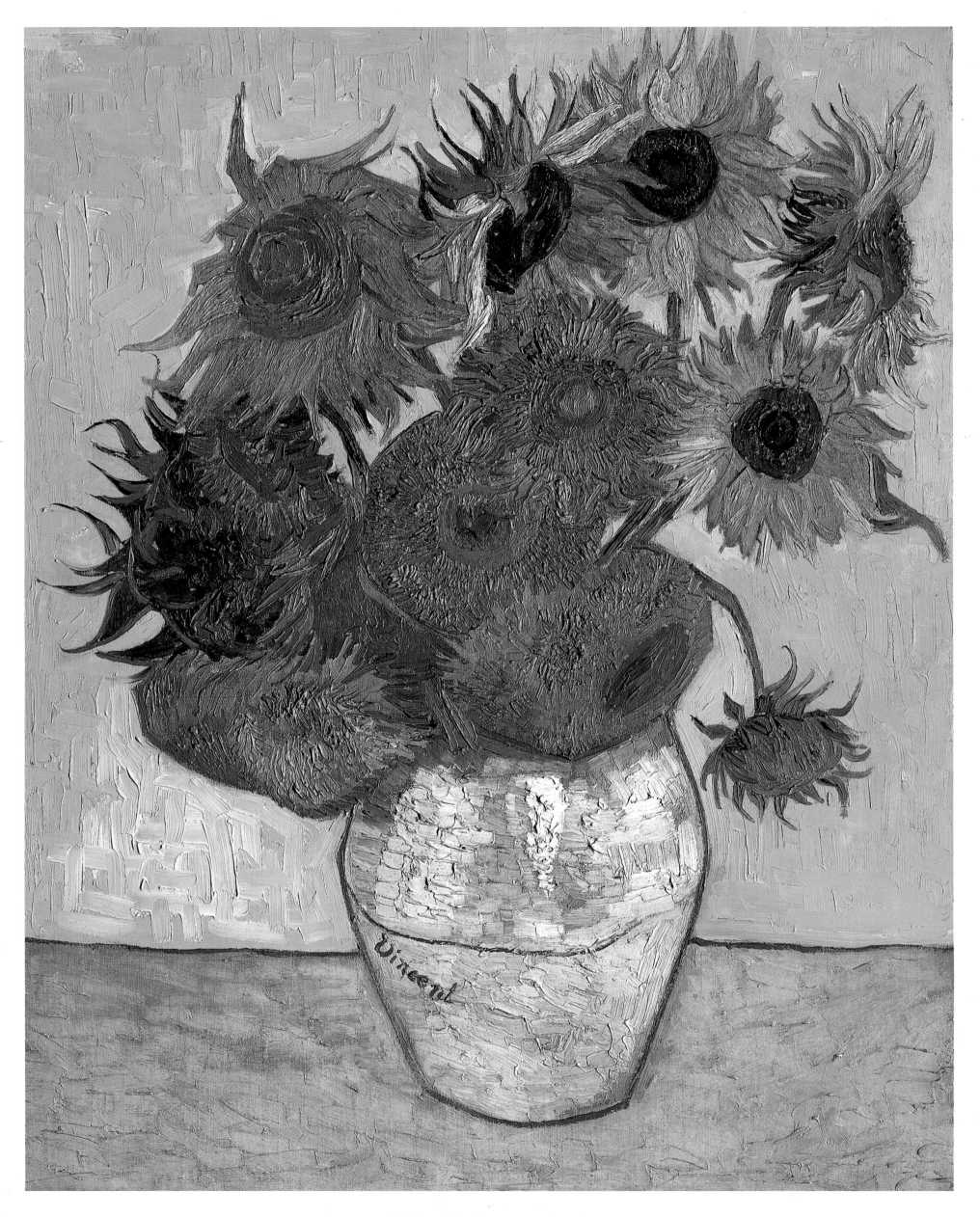

Vincent van Gogh · Vase with twelve Sunflowers

Vincent van Gogh
Vase with twelve Sunflowers, 1888
Zwölf Sonnenblumen in einer Vase
Douze tournesols dans un vase
Doce girasoles en un jarrón

Oil on canvas, 91 x 72 cm
Munich, Bayerische Staatsgemäldesammlungen, Neue Pinakothek

With extreme precision he has captured his flowers, yet the pastose application of colour, the confused arrangement of outstretched leaves, and the inner luminosity of the light blue background suggest a significance which goes far beyond that of the mere image of the flowers.

Akribisch genau sind die Blumen erfaßt, doch der pastose Farbauftrag, die wirr weggestreckten Blätter und die von innen heraus kommende Leuchtkraft vor dem hellblauen Hintergrund geben der Darstellung eine über die Abbildung von Blumen hinausgehende Bedeutung.

Les fleurs sont rendues de façon minutieuse, mais la touche pâteuse, les feuilles disposées en désordre, la lumière irradiant la corolle et le fond bleu clair donnent à la représentation une signification allant au-delà de l'image florale.

Las flores están trazadas con meticulosa precisión; sin embargo la pastosa aplicación del color, la caótica disposición de las hojas, la fuerza luminosa que surge de su interior ante el fondo azul celeste dotan al cuadro de un significado que va mucho más allá de la simple reproducción de unas flores.

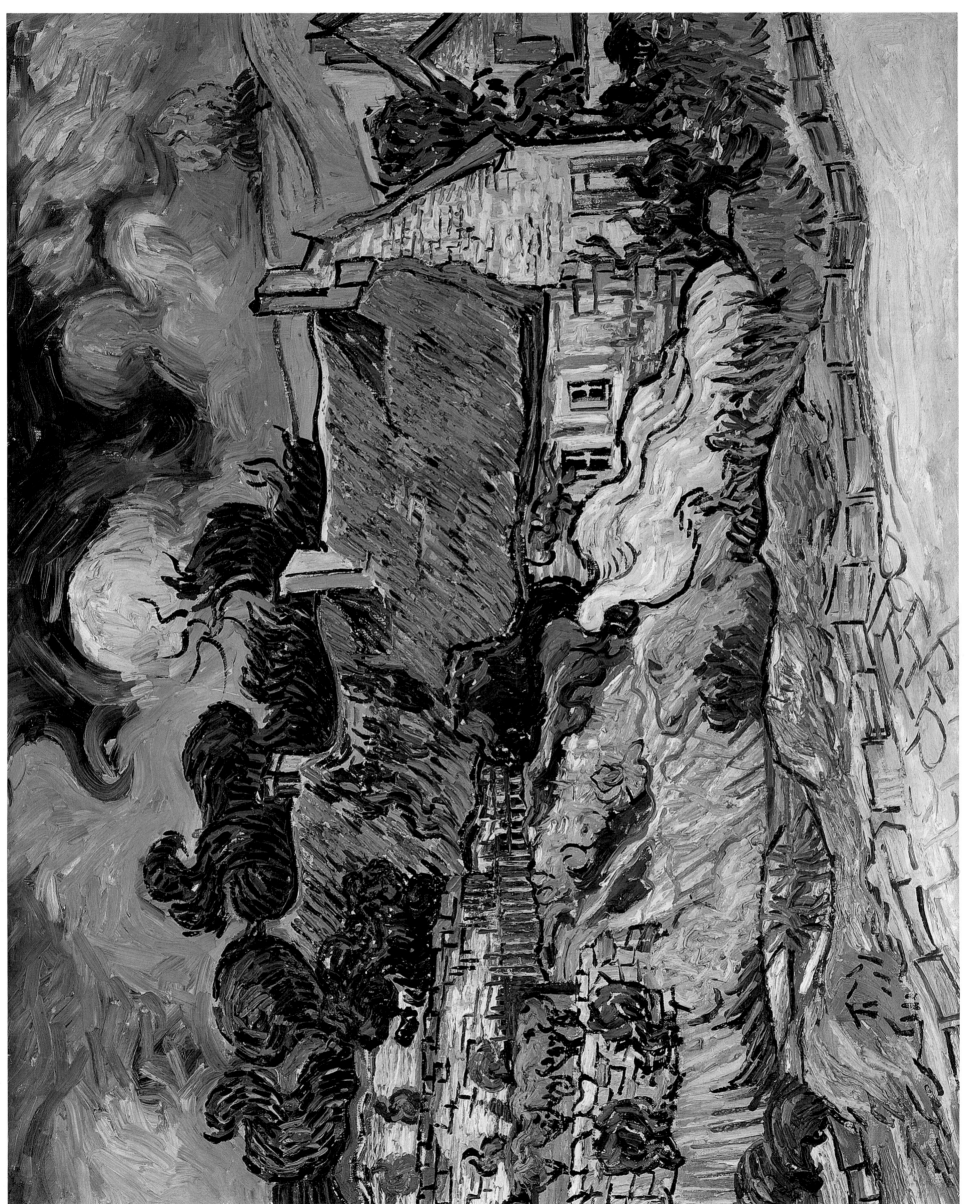

Vincent van Gogh · Thatched Cottages in Cordeville

Vincent van Gogh
Thatched Cottages in Cordeville, 1890
Strohgedeckte Häuser in Cordeville
Chaumières à Cordeville
Casas con tejado de paja en Cordeville

Oil on canvas, 73 x 92 cm
Paris, Musée d'Orsay

Despite the idyllic motif of the old, thatched roofs of the farm houses with
vegetable garden, fence and wall, a great unrest is diffused over the whole of
the painting by the bushes and dark trees.

Das alte strohbedeckte Bauernhaus mit Gemüsegarten, Zaun und Mauer, mit
Buschwerk und dunklen Bäumen verbreitet trotz des idyllischen Motivs
große Unruhe im Bild.

La vieille ferme de chaume, le potager, la haie et le mur avec des buissons
et des arbres sombres donnent malgré le motif idyllique une impression
d'inquiétude au tableau.

La vieja granja cubierta de paja con la huerta, la valla y el muro,
rodeada de matorrales y árboles oscuros, da al cuadro una atmósfera de gran
intranquilidad, a pesar de lo idílico del tema.

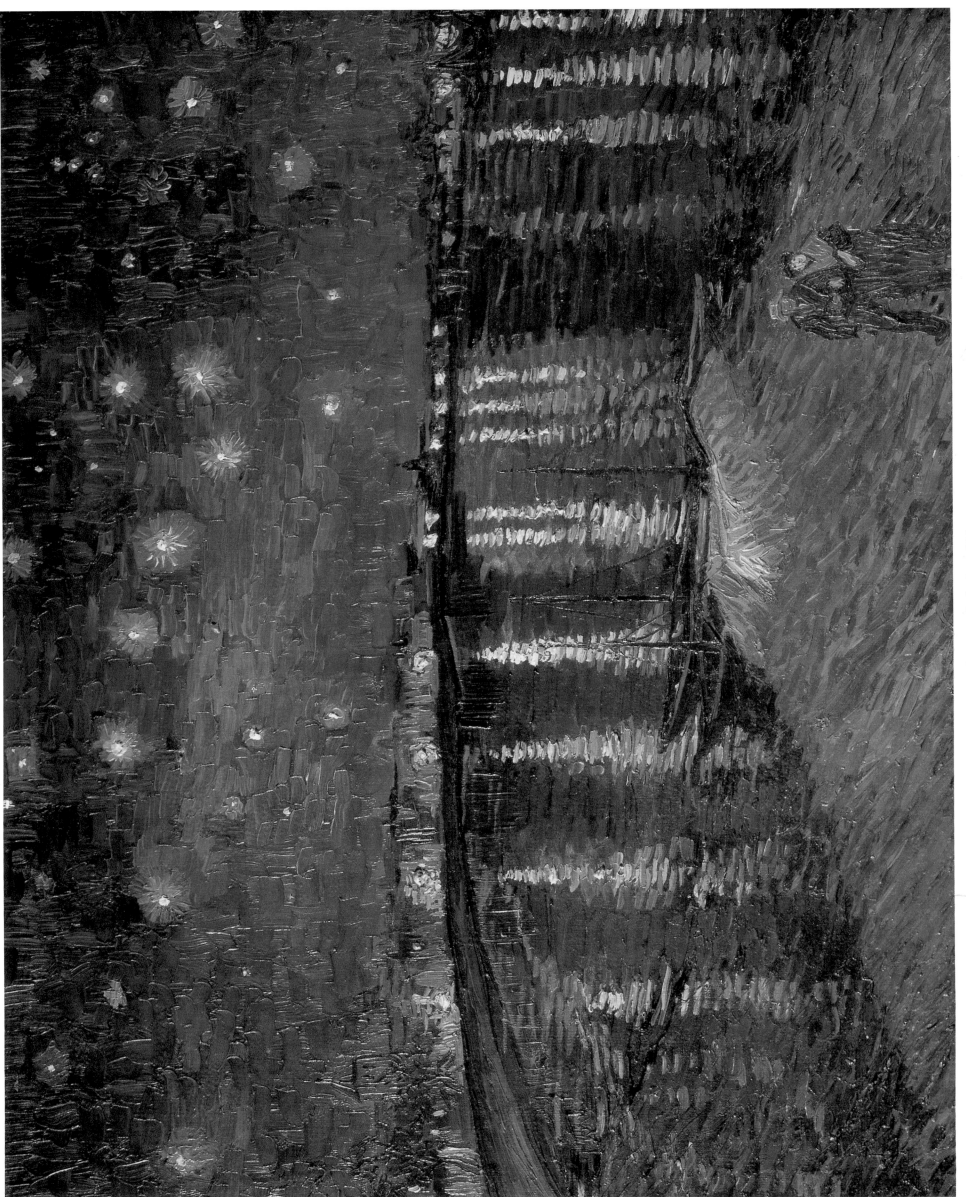

Vincent van Gogh · Starry Night

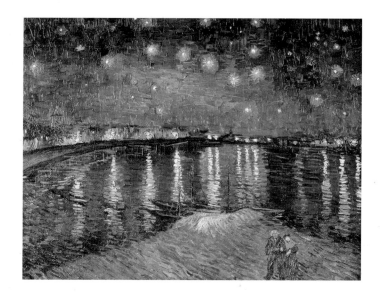

Vincent van Gogh
Starry Night, 1888
Sternennacht
La nuit étoilée
Noche estrellada

Oil on canvas, 72.5 x 92 cm
Paris, Musée d'Orsay

"I experience a period of frightening clarity in those moments when nature
is so beautiful. I am no longer sure of myself, and the paintings appear as
in a dream."

„Ich erlebe eine schreckliche Klarheit in den Momenten, in denen die Natur
so schön ist. Ich bin mir nicht mehr meiner selbst bewußt, und die Bilder
kommen wie im Traum."

« Je vis une clarté effrayante au cours des moments où la nature est si belle. Je
ne suis plus conscient de moi-même et les images arrivent comme un rêve. »

«Experimento una increíble claridad en los momentos en que la naturaleza es
tan hermosa. Pierdo la conciencia de mí mismo y las imágenes vienen como
en un sueño».

VINCENT VAN GOGH